How to Draw
Wild Animals
In Simple Steps

First published in Great Britain 2010

Search Press Limited
Wellwood, North Farm Road,
Tunbridge Wells, Kent TN2 3DR

Reprinted 2012, 2014

ISBN: 978-1-84448-573-4

Printed in Malaysia.

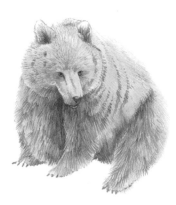

*To my darling Charlotte, my family and
friends, and to the wildlife of the world, you
inspire me always.*

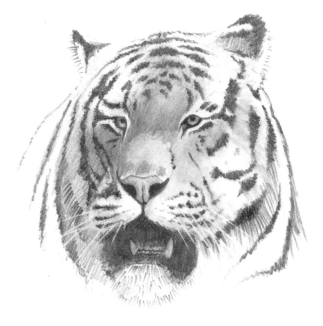

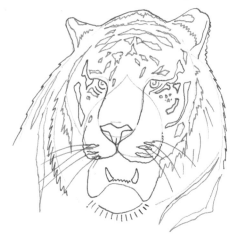

Illustrations

How to Draw
Wild Animals
In Simple Steps
Jonathan Newey

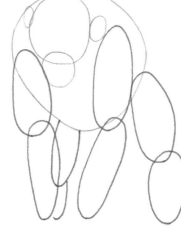

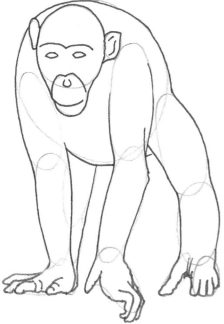

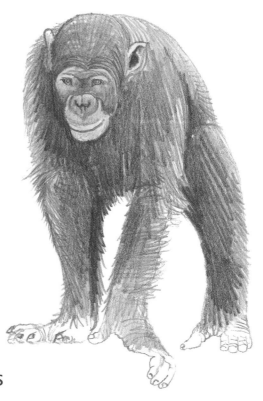

Search Press

Introduction

Using step-by-step techniques, this book shows how to draw a good selection of wild animals, starting off with basic shapes and lines and building up forms to create completed images. I have included a mixture of poses, including details of heads and shoulders, as well as full body illustrations. Movement is important and several of the animals are shown either walking or running.

Each sequence begins with simple shapes drawn in pencil. For each subsequent step new lines are drawn using brown pencil, with the previous pencil lines left in as a guide. As the brown pencil lines may be difficult to erase, you should use graphite pencil throughout all the stages apart from the final picture, where I have used coloured pencils. You can use, of course, whatever medium you prefer. All of the initial line drawing stages can be used as a basis for most drawing and painting mediums.

At the bottom of each page are two illustrations: the penultimate stage and the finished drawing. The penultimate stage is drawn in pencil showing the tone, or form and texture, of the animals. If you want to take the drawing to the finished colour stage, this tonal image will help you with your study. Tone is important when drawing anything, and a pencil study will indicate shape and form much better than if you use colour. The tonal qualities can then be translated into colour in the final drawing or painting.

Draw as many of these animals as possible and, if you can, use a variety of mediums. The more you practise, the easier the drawing process will become. You may prefer to use your own source material, or you might want to draw a picture of your pets if they can sit still long enough! Visit zoos and wildlife parks for inspiration; local libraries can be a rich source of ideas, or surfing the internet can provide you with reference. To gain further knowledge and for more inspiration, look at the work of other artists. David Shepherd, Robert Bateman, Alan Hunt and Terry Isaac are a few of my favourites. Do be aware though: if you want to use someone else's photographs, you have to ask for permission to do this. If you do not, you could well be in breach of the copyright laws.

When you feel you have practised enough and if you are feeling more confident, spend time drawing as many different types of animal as you can. Each one will be different: even male and females of the same species can vary considerably. You may want to include reptiles, insects and domestic animals. Whatever you are drawing, the same principles apply: start off with simple shapes, and build up images in easy stages. Finally, use this book to practise and develop your observation skills. Draw what you see, not what you think is there. Above all else, enjoy yourself.

Happy drawing!

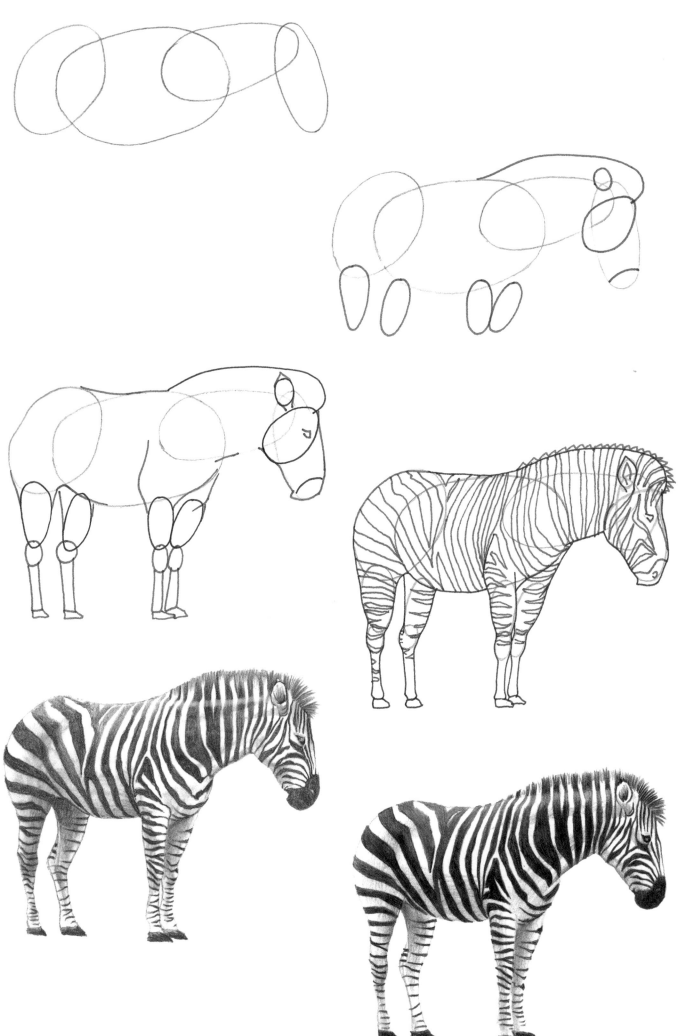

5

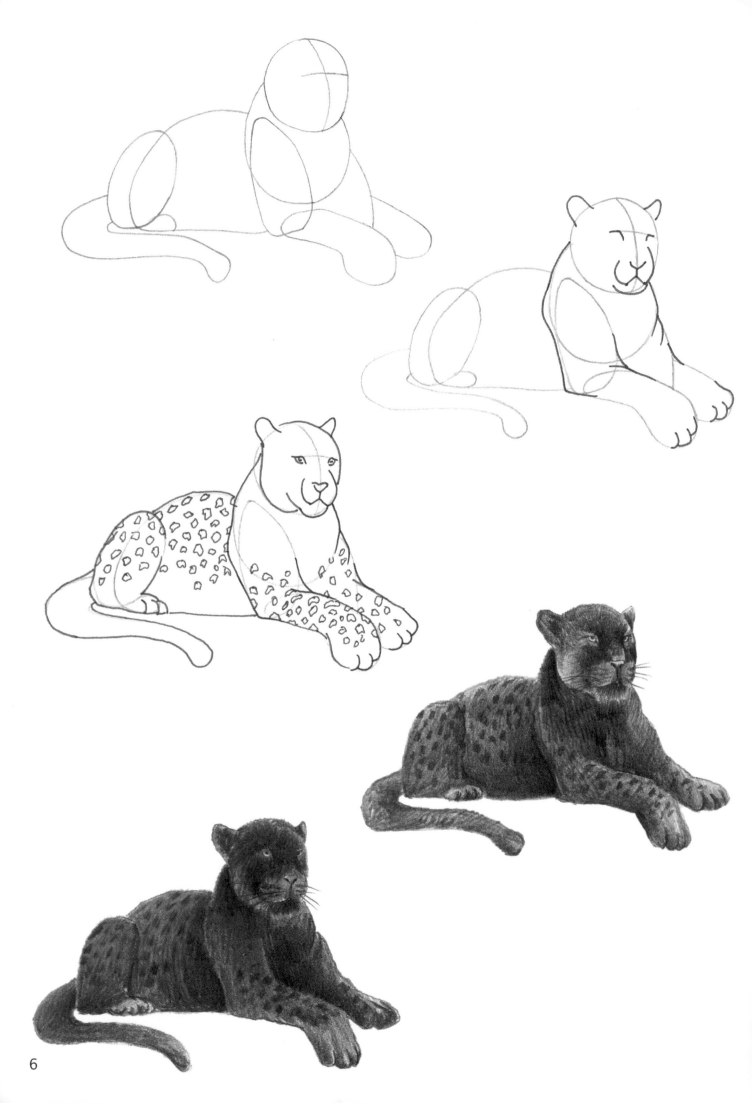

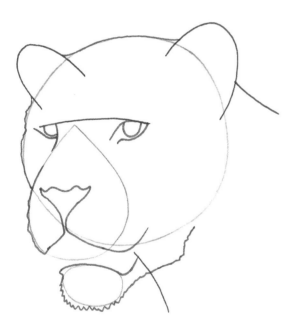

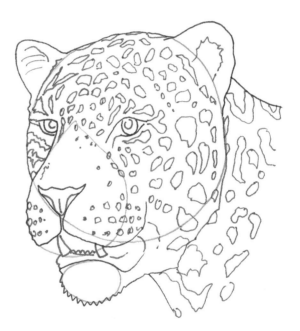

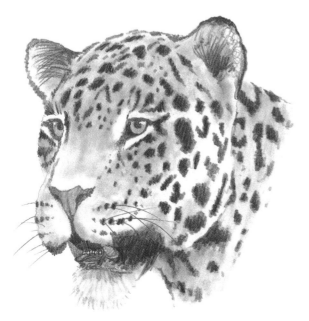

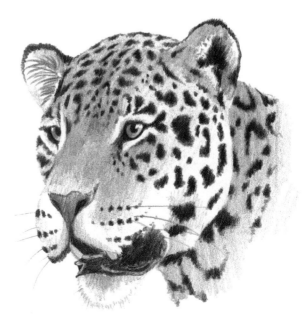

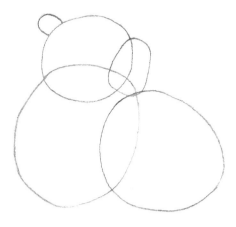

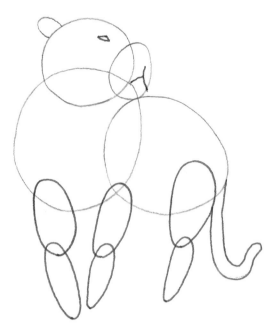

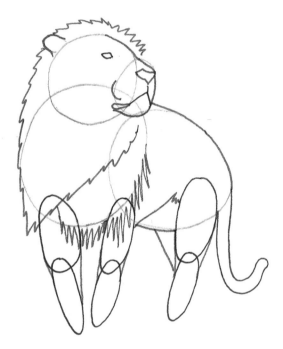

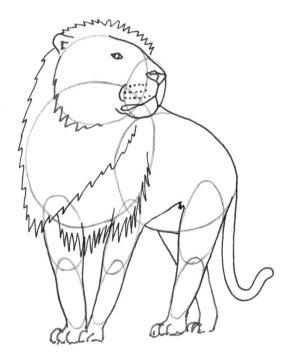

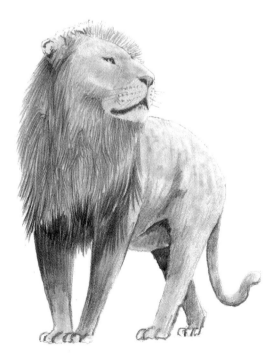

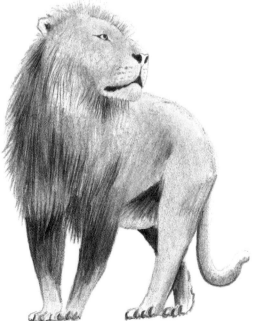

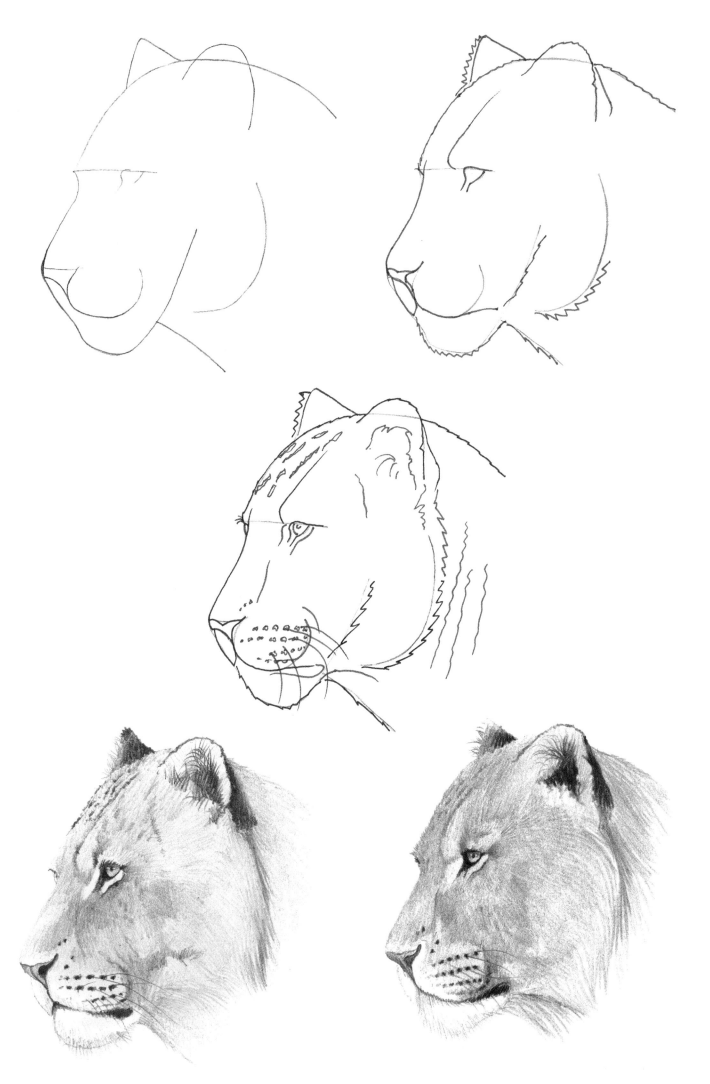

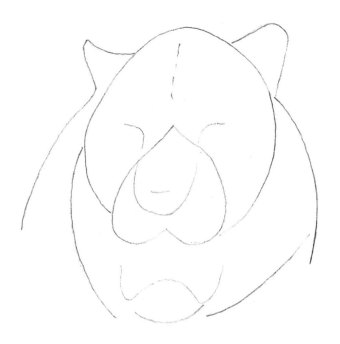
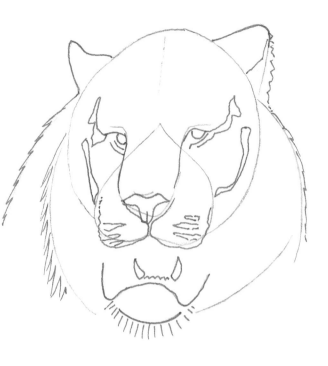
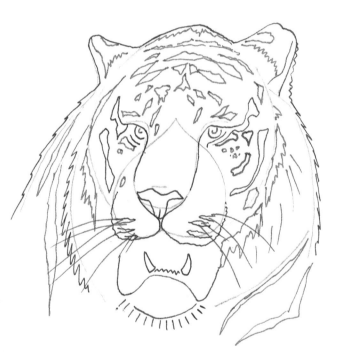
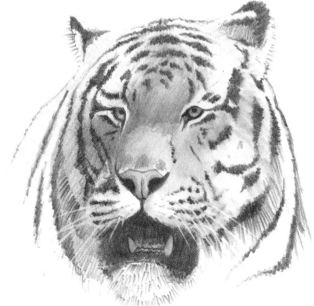
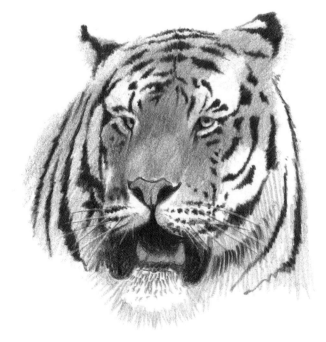

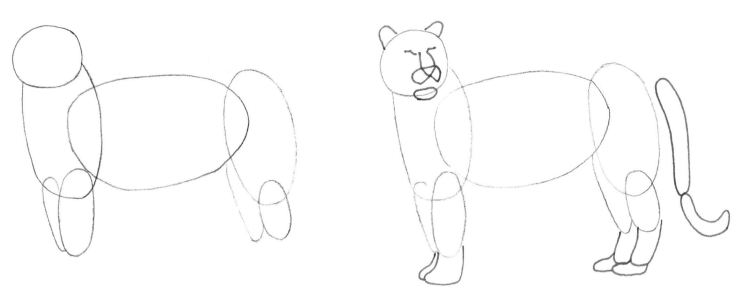

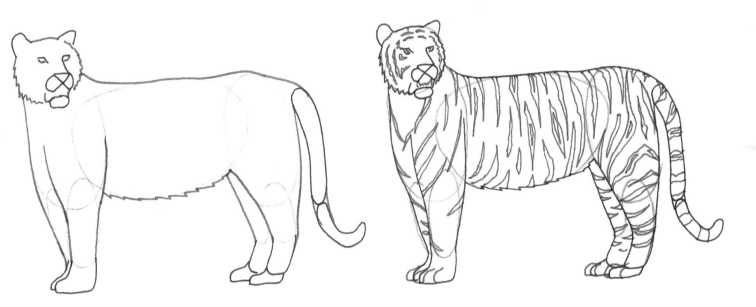

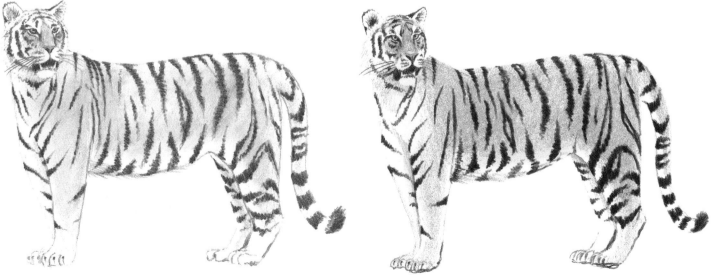

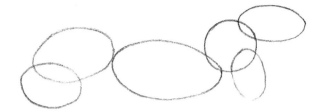

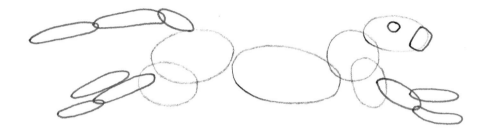

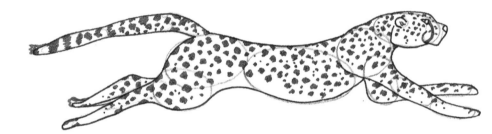

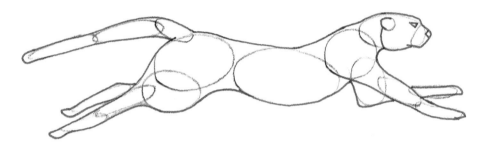

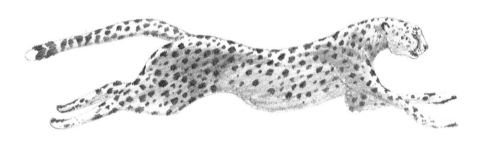

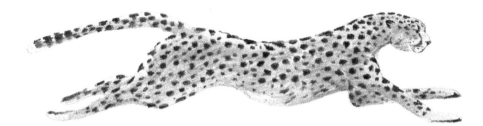

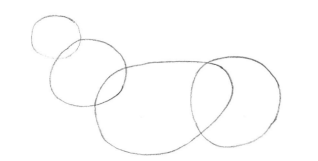
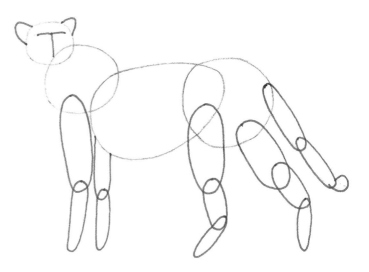
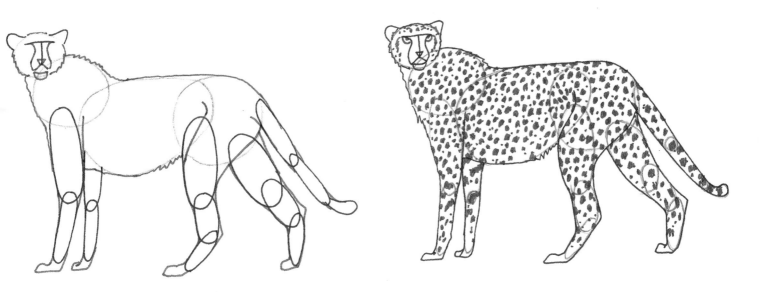
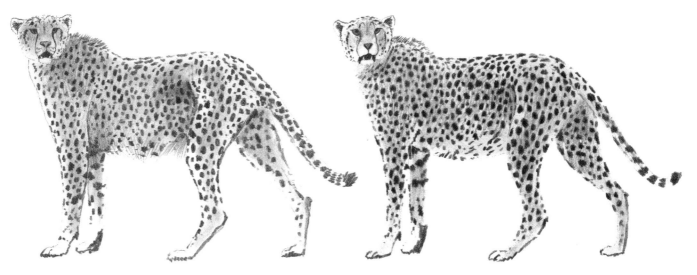

13

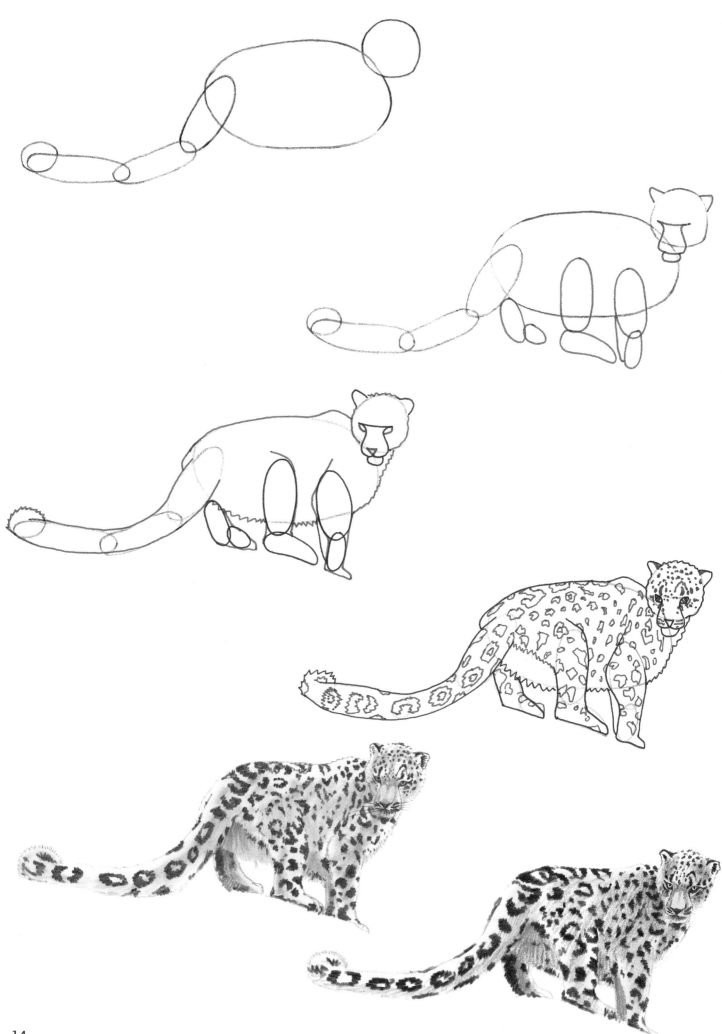

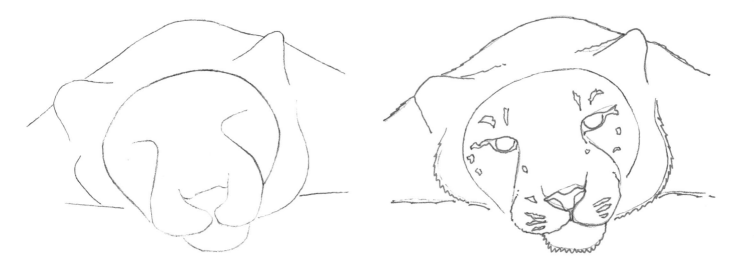

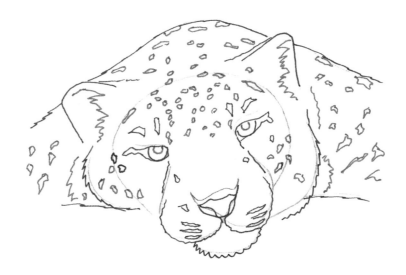

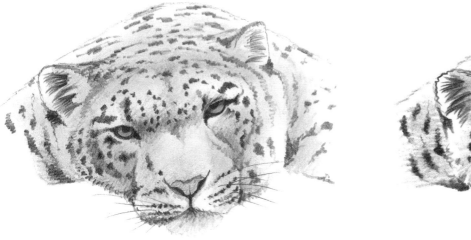

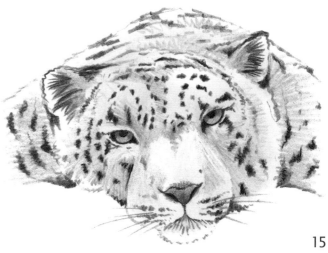

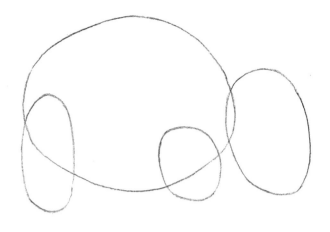

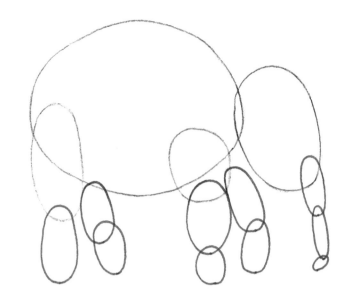

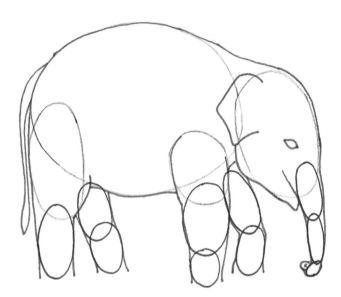

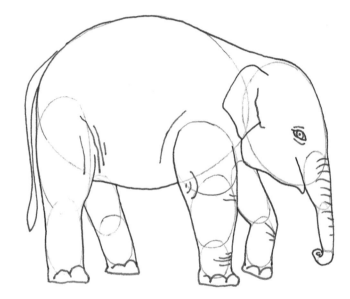

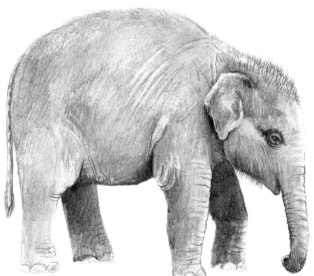

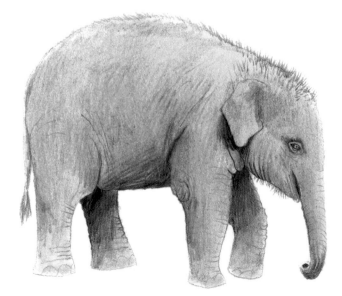

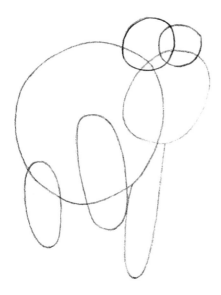

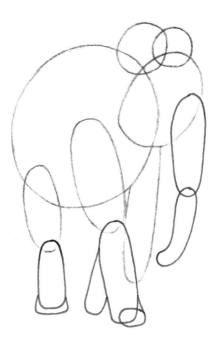

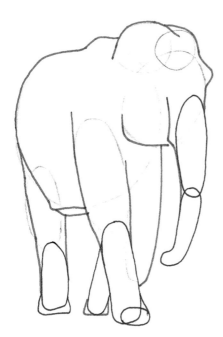

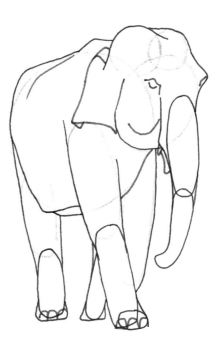

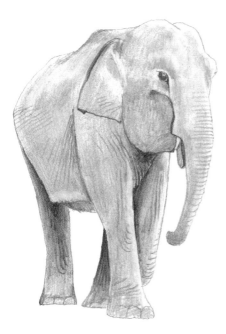

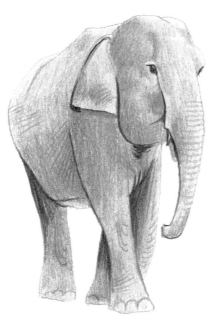

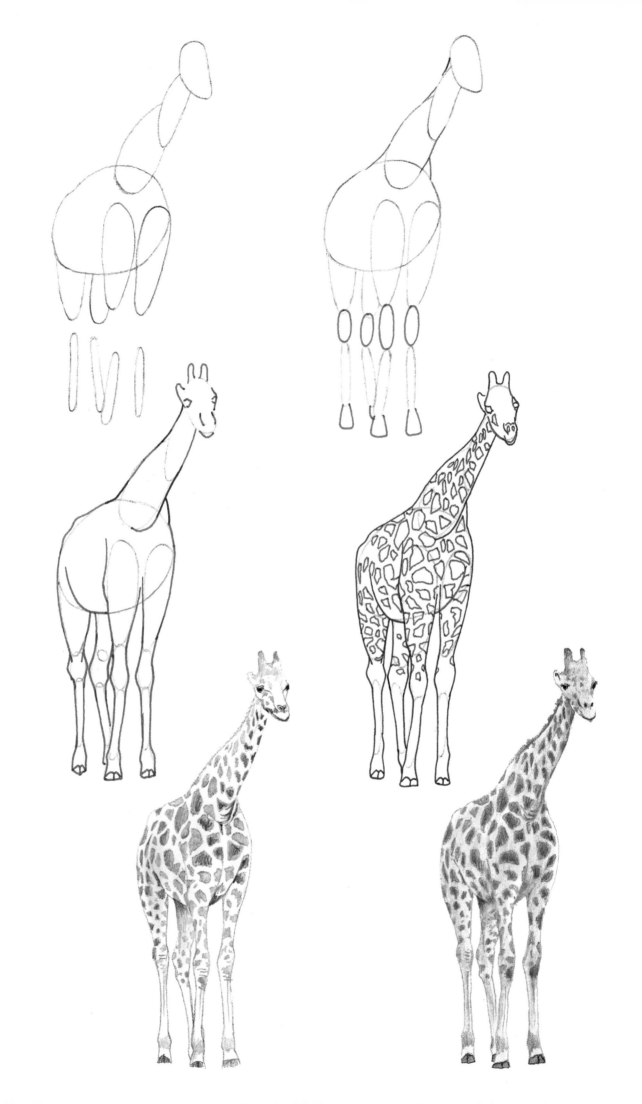

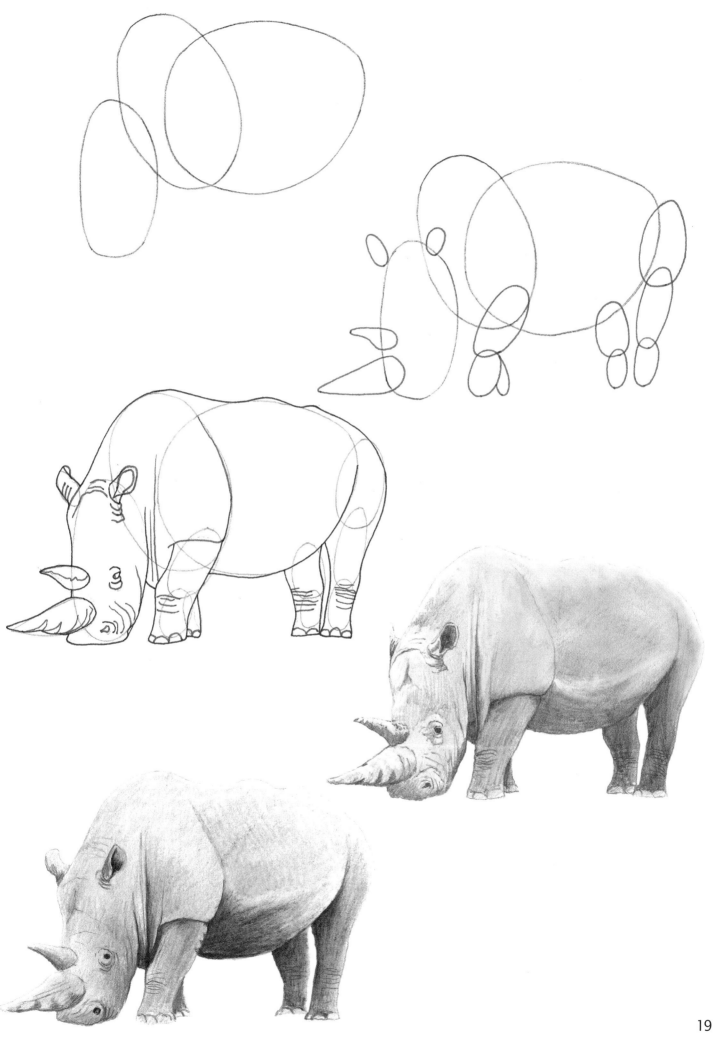

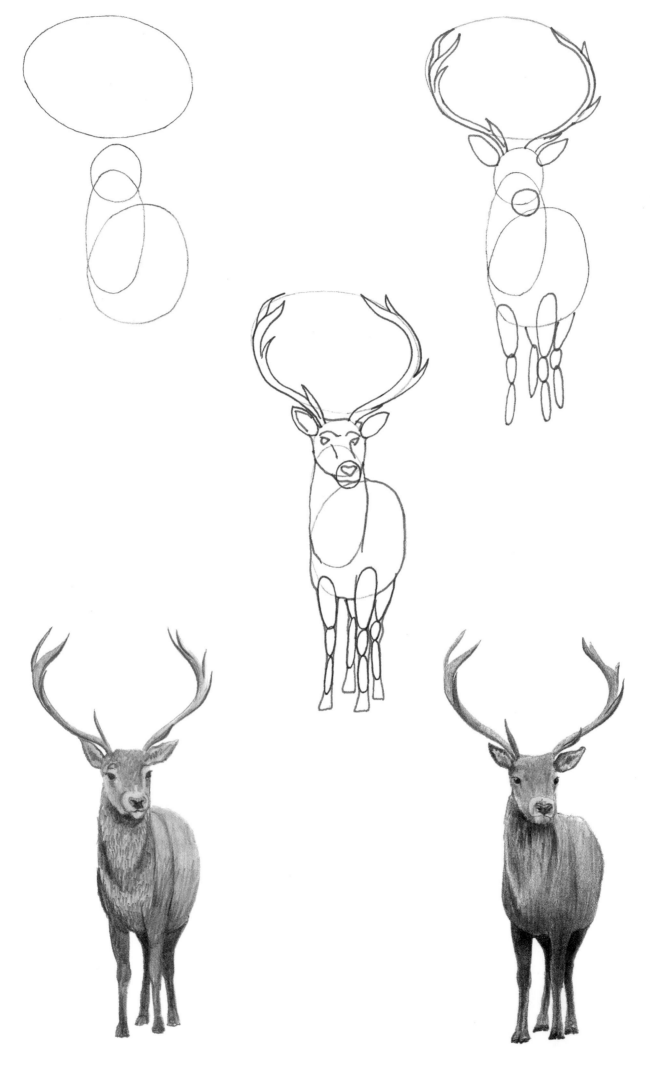

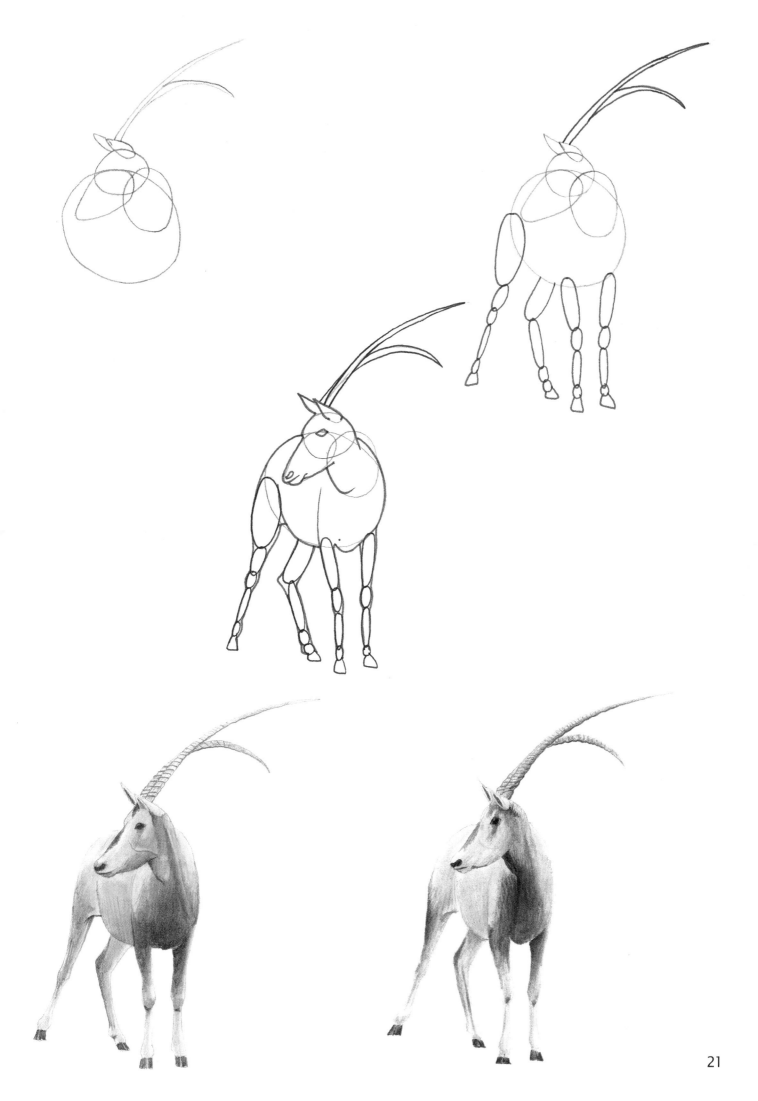

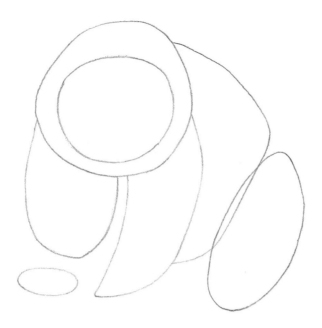

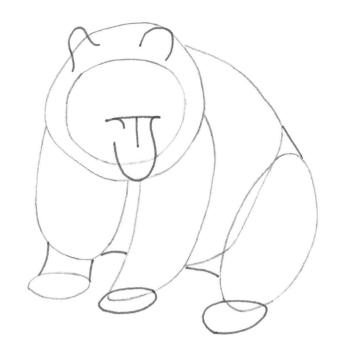

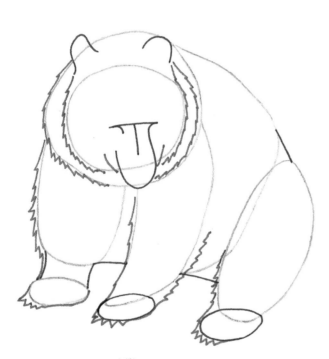

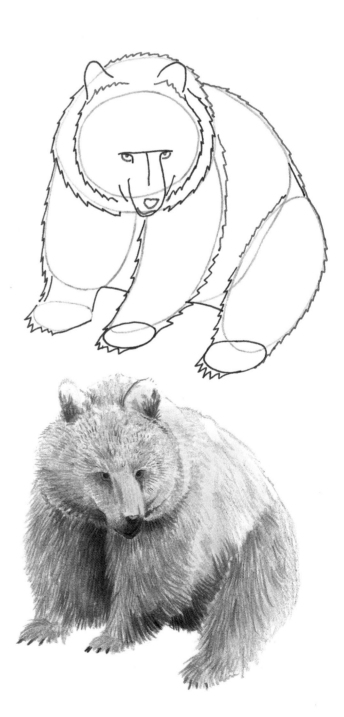

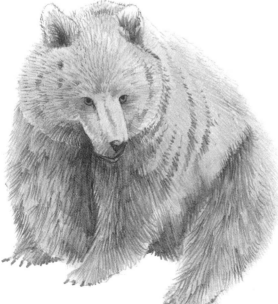

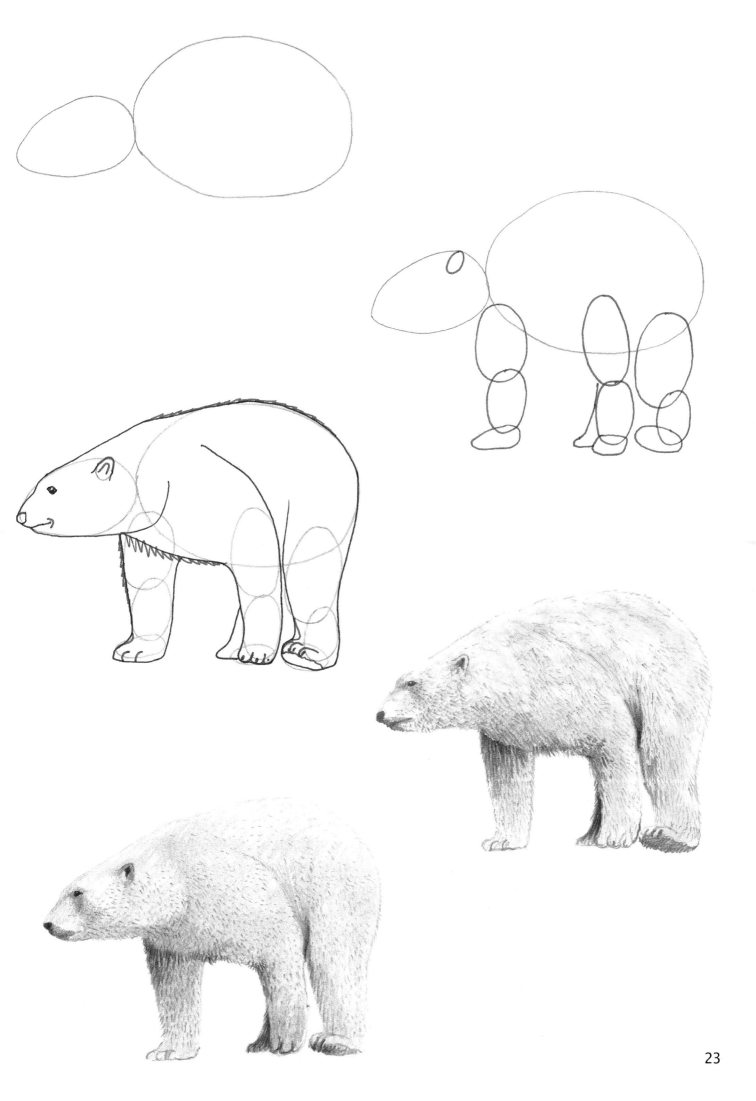

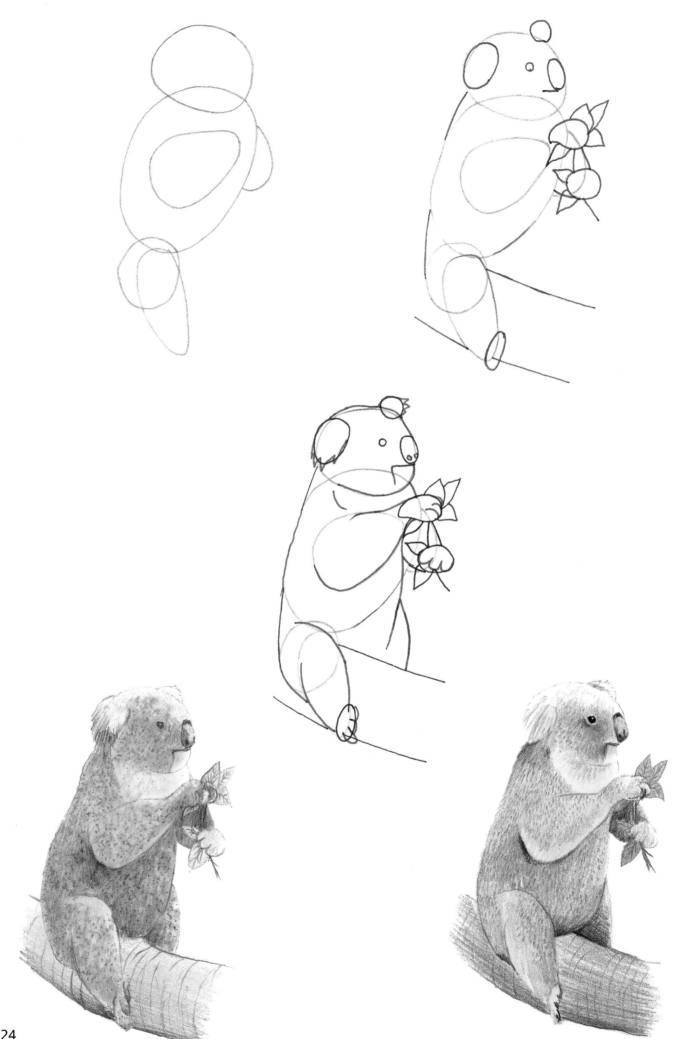

24

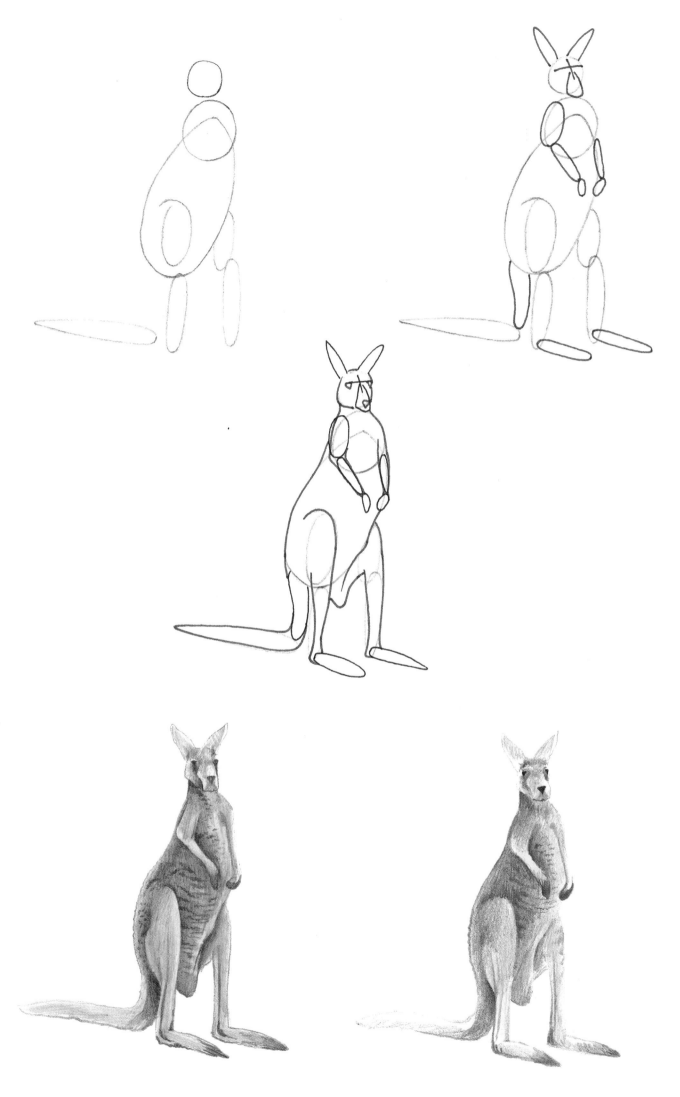

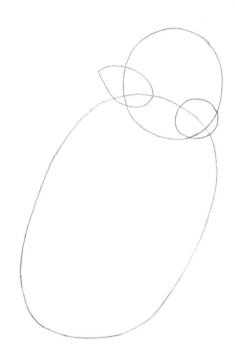

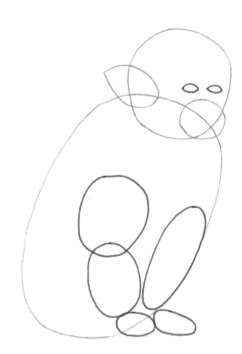

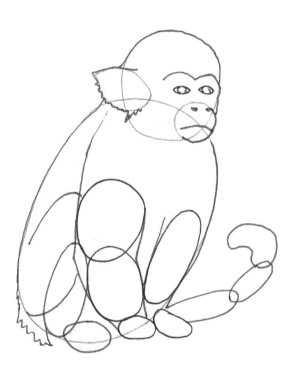

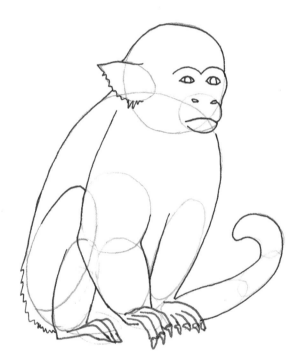

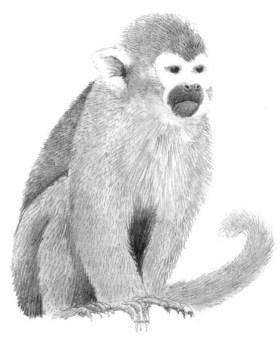

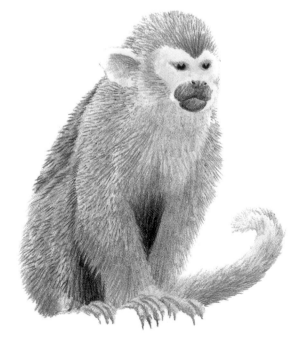

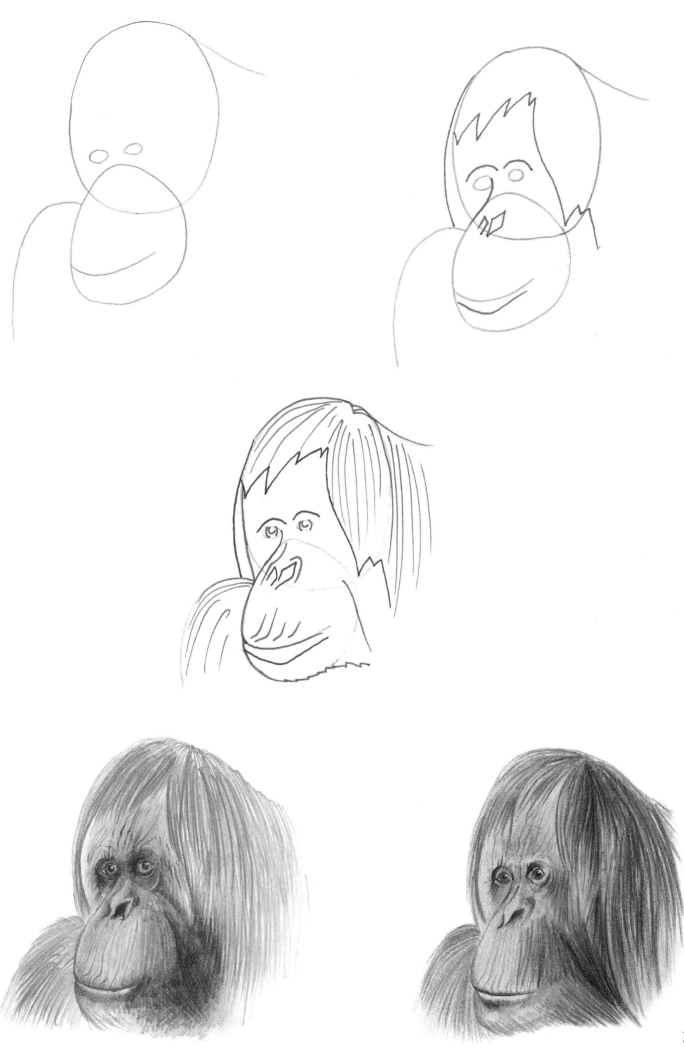

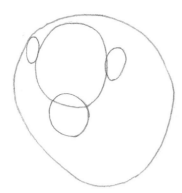

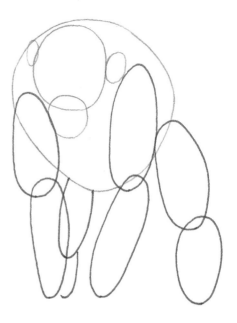

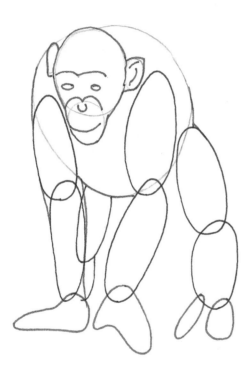

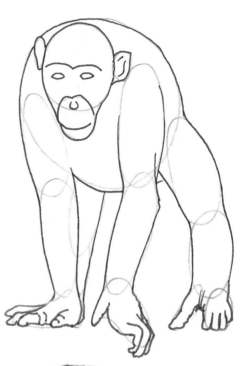

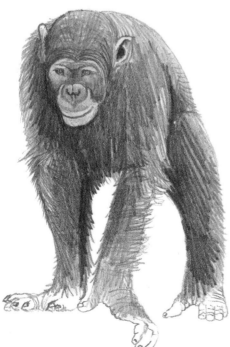

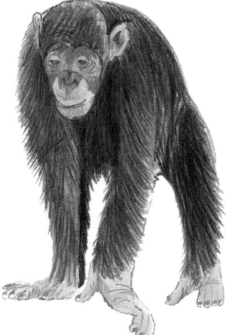

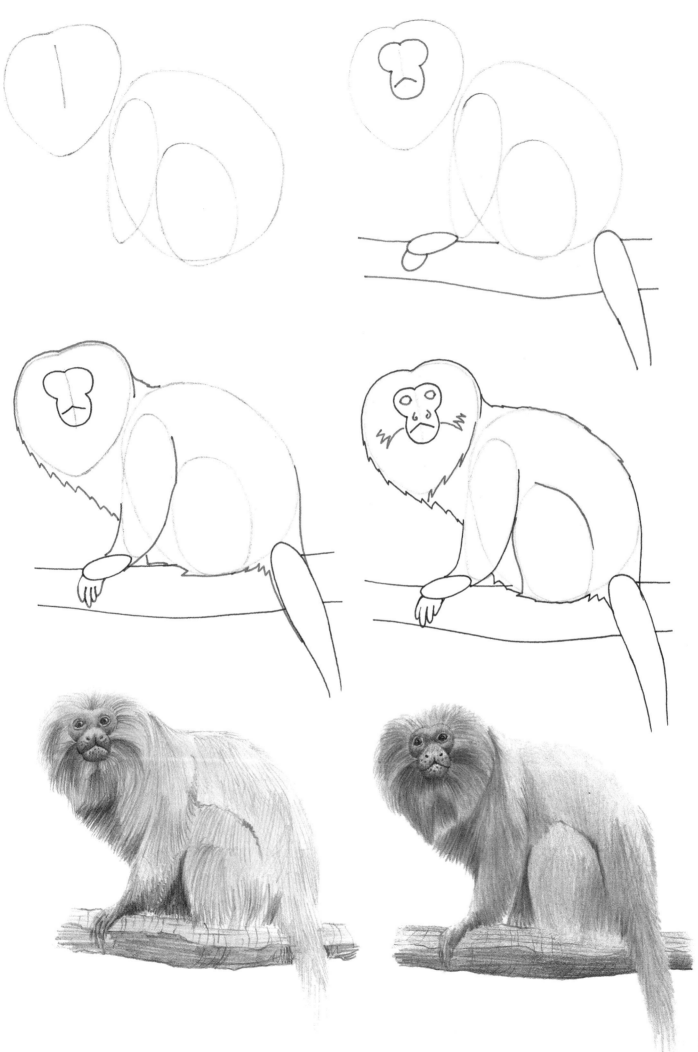

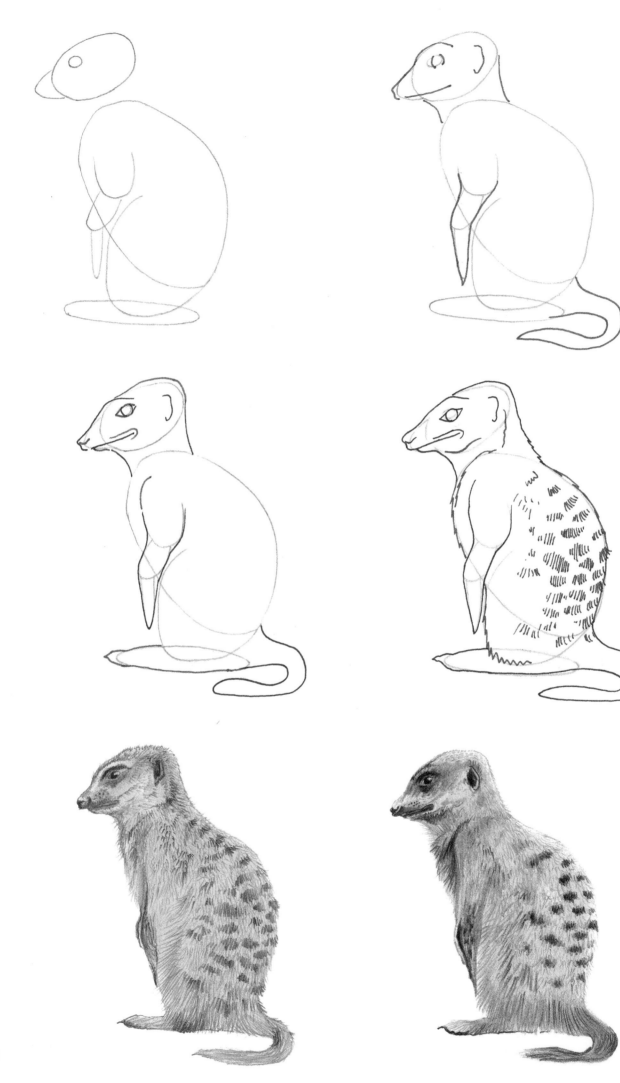

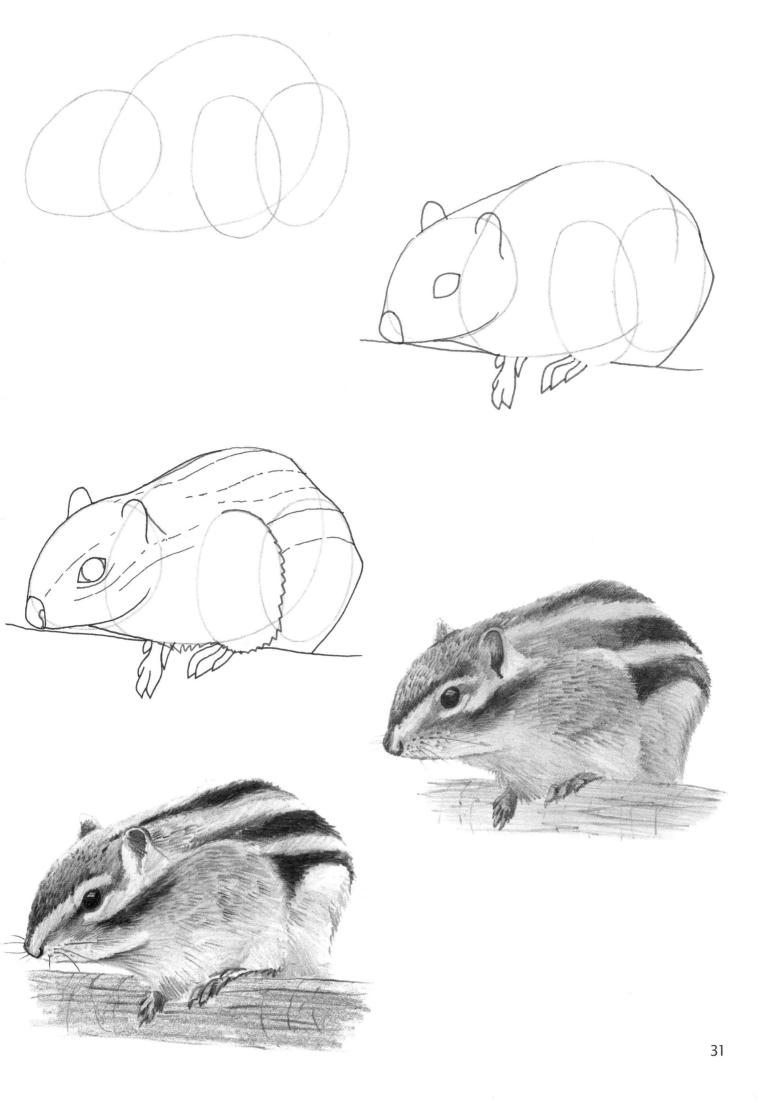

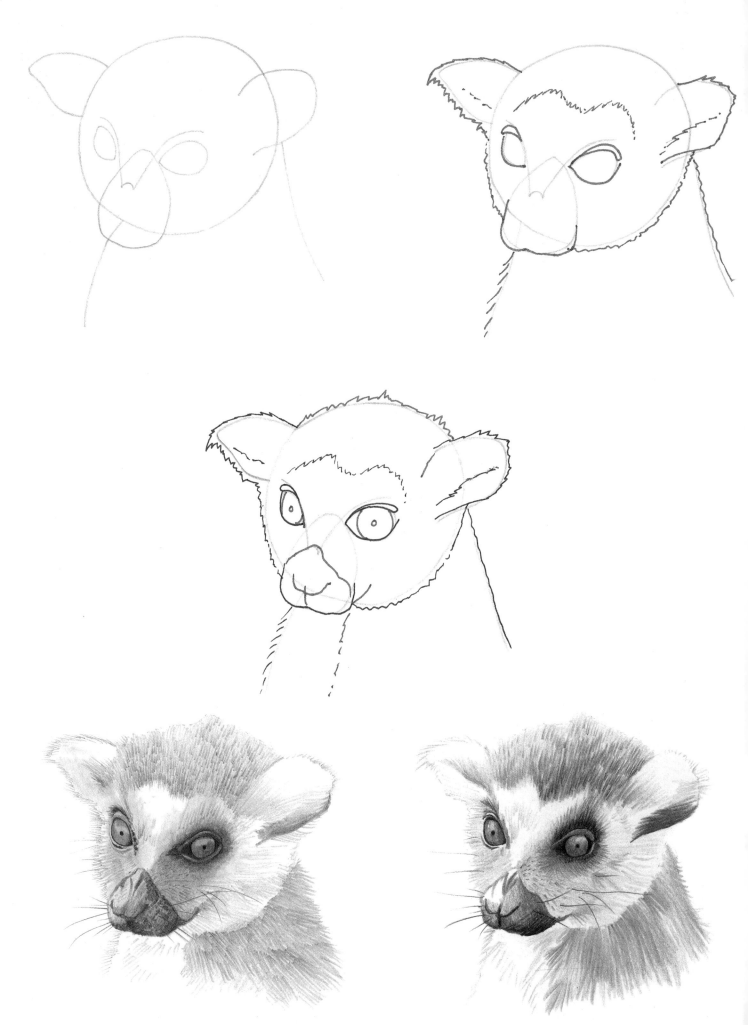